RAYMOND BRIGGS

Ethel & Ernest

JONATHAN CAPE
London

For my Mother & Father

This paperback edition first published in 2002

1 3 5 7 9 10 8 6 4 2

Copyright © 1998 Raymond Briggs

Raymond Briggs has asserted his right
under the Copyright, Designs and Patents Act 1988
to be identified as the author of this work

First published in the United Kingdom in 1998 by Jonathan Cape
Random House, 20 Vauxhall Bridge Road, London SW1V 2SA

Random House Australia (Pty) Limited
20 Alfred Street, Milsons Point, Sydney
New South Wales 2061, Australia

Random House New Zealand Limited
18 Poland Road, Glenfield
Auckland 10, New Zealand

Random House South Africa (Pty) Limited
Endulini, 5a Jubilee Road,
Parktown 2193, South Africa

Random House UK Limited Reg No 954009
A CIP catalogue record for this book
is available from the British Library

ISBN 0 224 06446 0

Printed and bound in Germany
by Appl Druck, Wemding

Ethel & Ernest

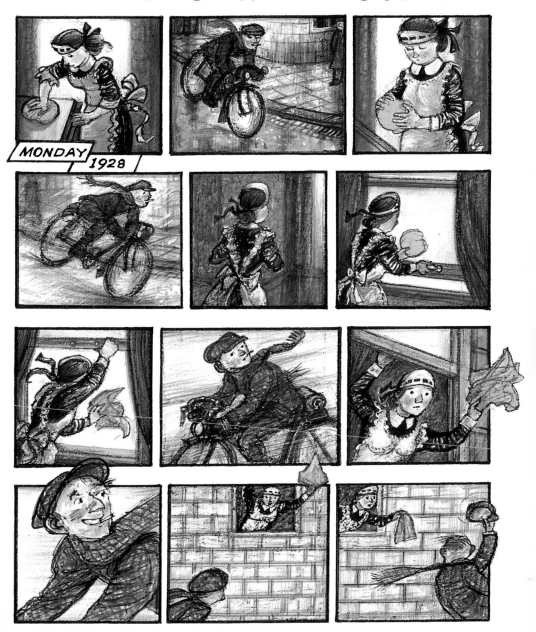

MONDAY 1928

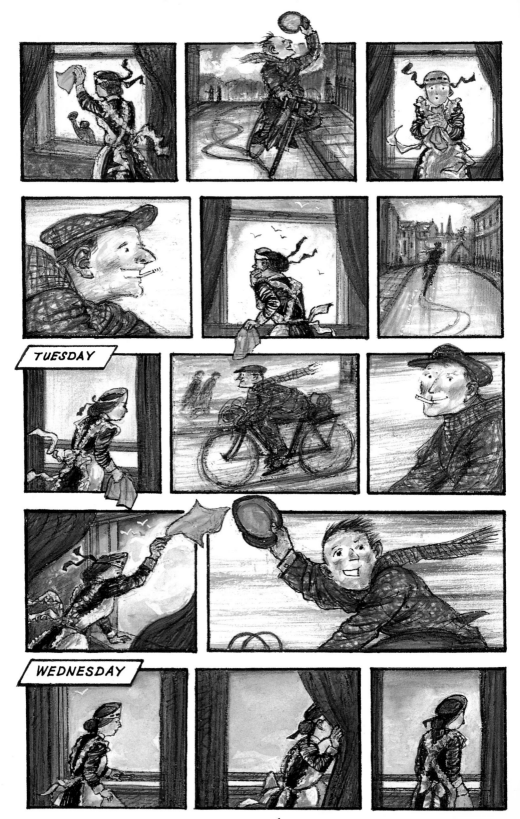

TUESDAY

WEDNESDAY

4

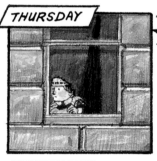

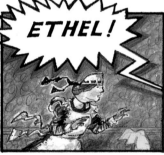

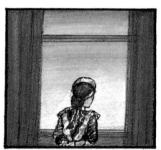

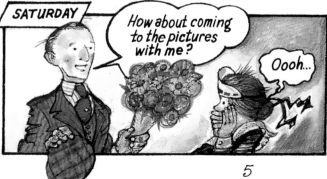

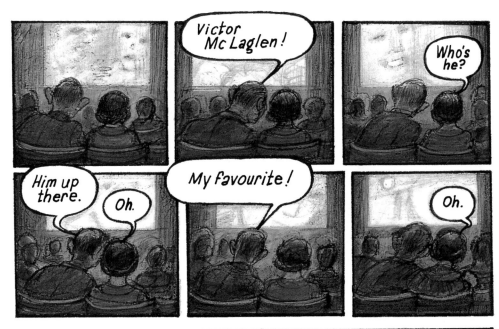

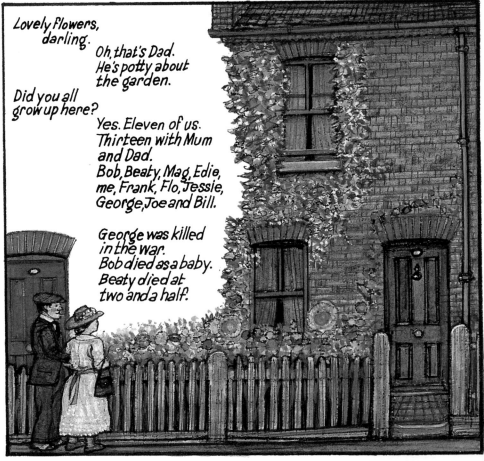

You haven't asked me to **YOUR** home, yet, dear.

Yeah, well... It's not as nice as yours, darling.

Our street's full of diddicois and costermongers. Horses and carts all down the road... Fruit and veg all over the place... Scrap iron, rag and bone men... There's three pubs... Blokes playing cards on the pavement... and there's horse – er... horse manure everywhere. There's fights outside the pubs – women, too ... The coppers won't go down there. The last one that did go, they bashed him up then sat on him and blew his whistle to fetch more coppers. It's not **YOUR** cup of tea, darling.

Oh, Ernest, dear.

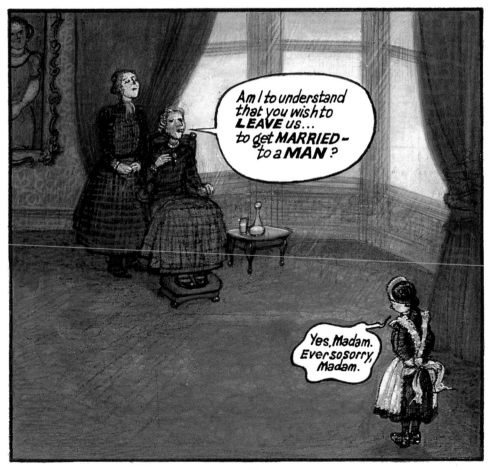

Am I to understand that you wish to **LEAVE** us... to get **MARRIED** – to a **MAN**?

Yes, Madam. Ever so sorry, Madam.

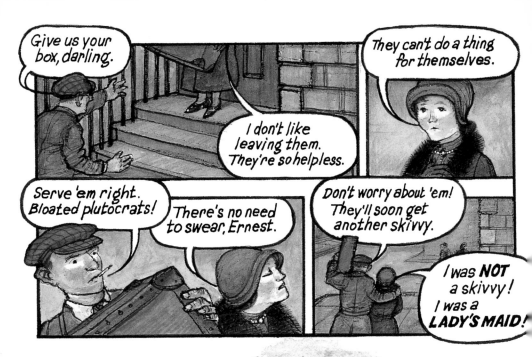

1930
~
1940

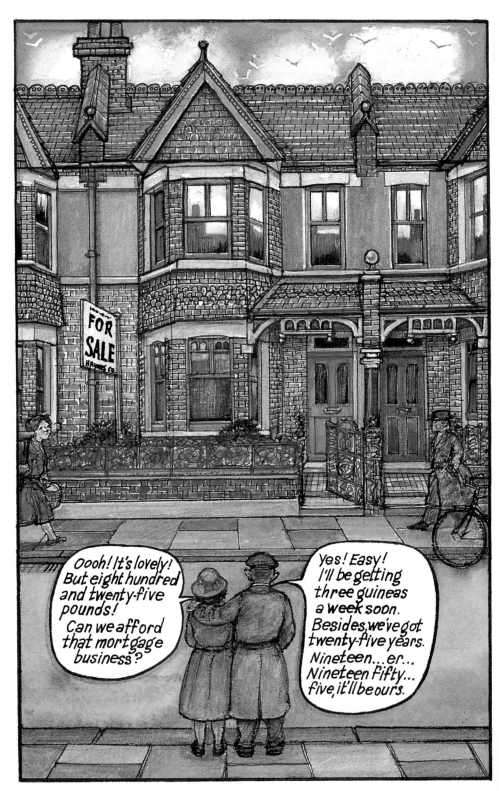

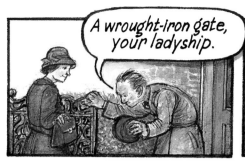

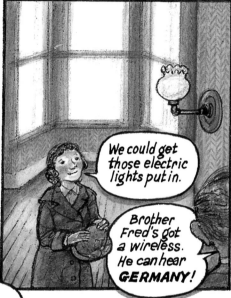

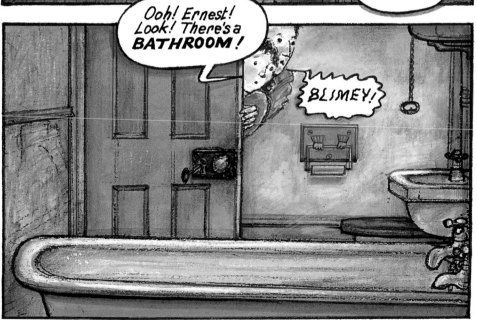

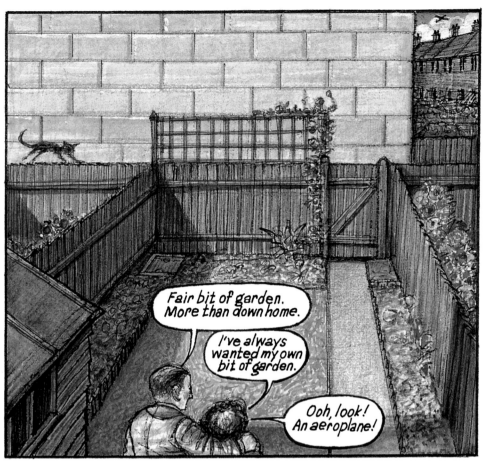

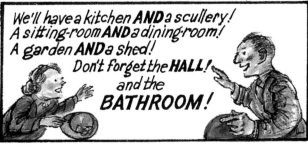

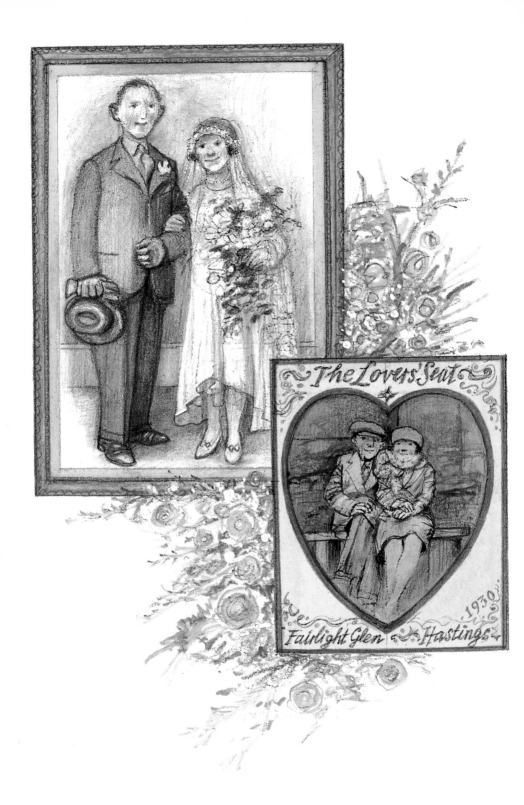

The Lovers Seat

Fairlight Glen — Hastings — 1930

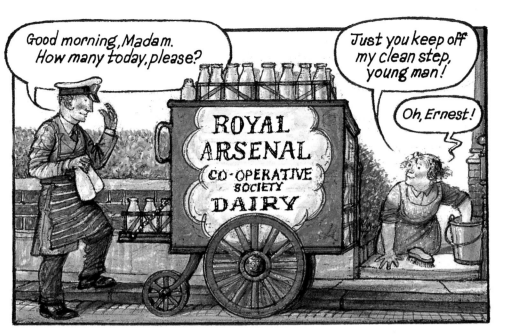

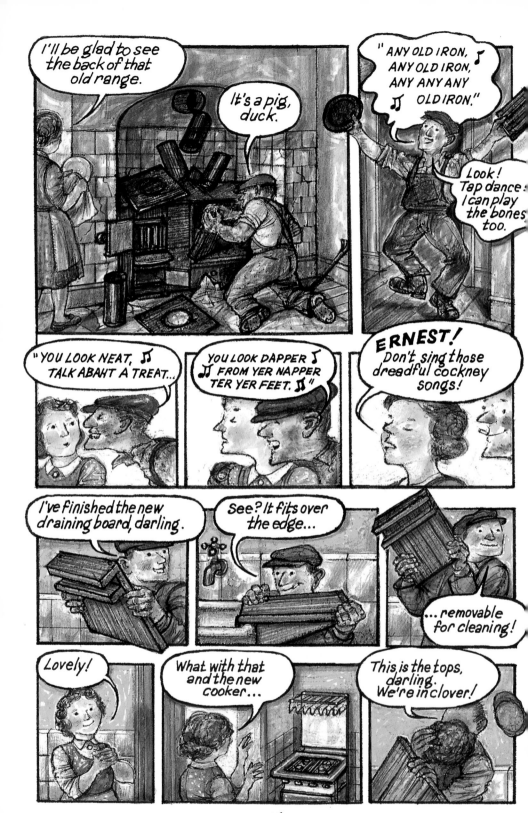

16

UGH! I hate coal under the stairs! Coal dust gets everywhere and—

it's SO **COMMON!** I'll build a brick bunker in the garden...

That'll be lovely.

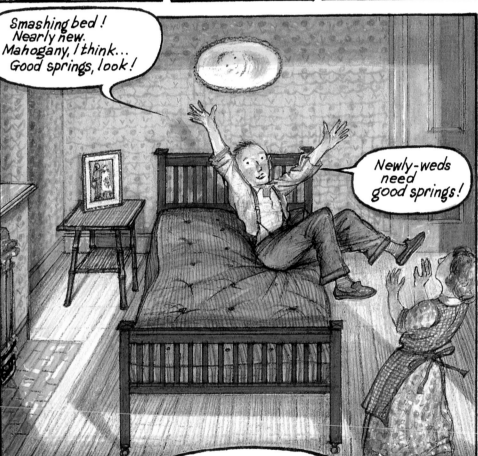

Smashing bed! Nearly new. Mahogany, I think... Good springs, look!

Newly-weds need good springs!

Come and try it out, darling...

Certainly **NOT**, Ernest! It's broad **DAYLIGHT!**

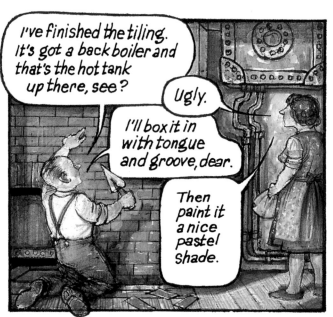

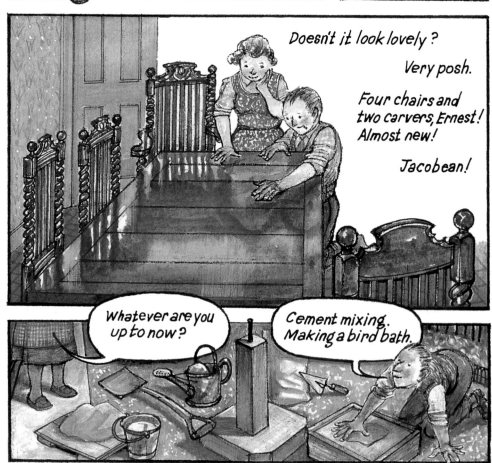

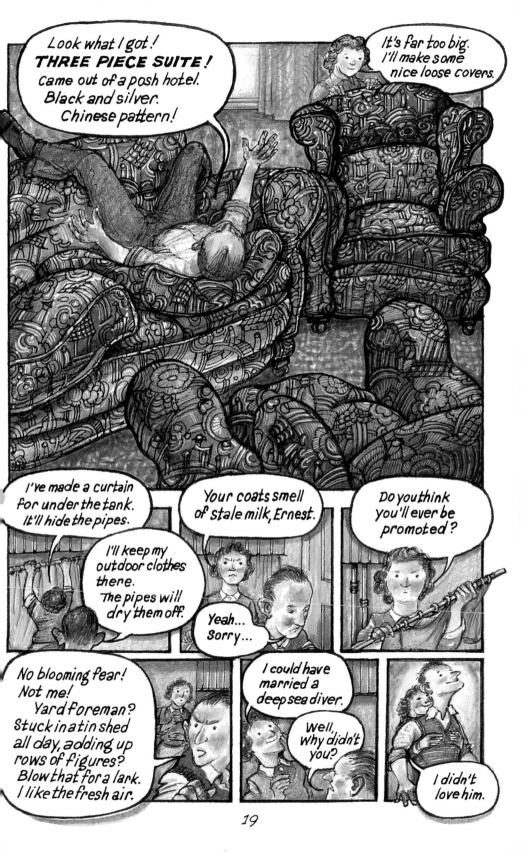

19

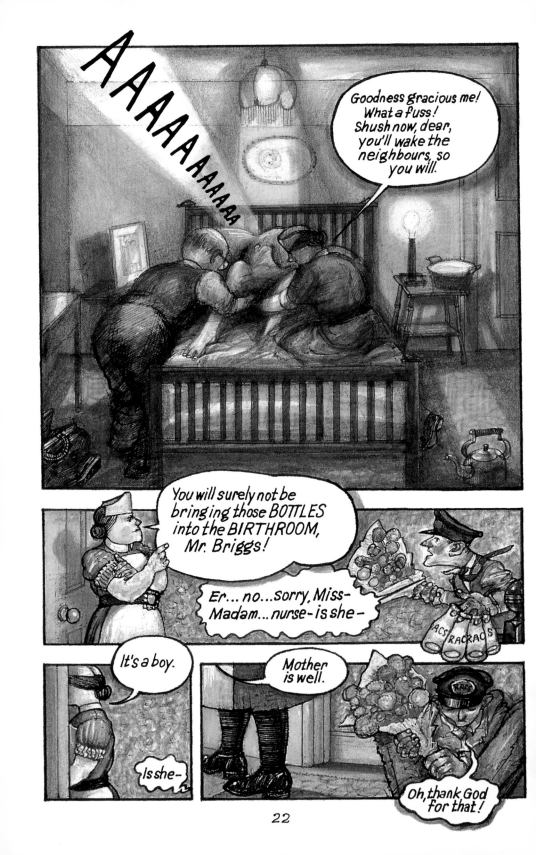

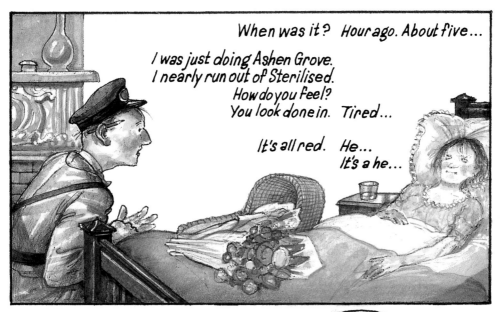

When was it? Hour ago. About five...

I was just doing Ashen Grove.
I nearly run out of Sterilised.
How do you feel?
You look done in. Tired...

It's all red. He...
It's a he...

Mr. Briggs, a word?

It was touch and go.

Oh?

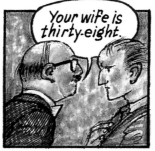

Your wife is thirty-eight.

There had better not be any more.

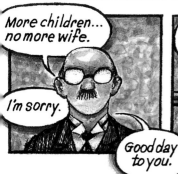

More children... no more wife.

I'm sorry.

Good day to you.

But we wanted a proper family...

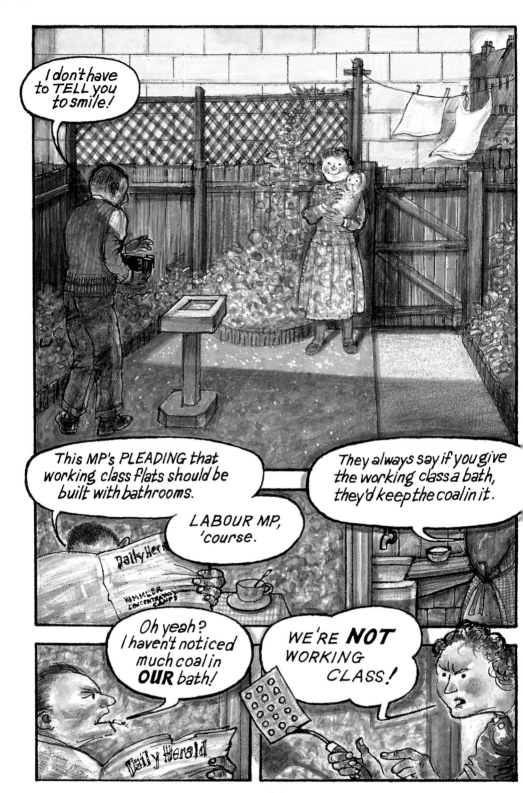

24

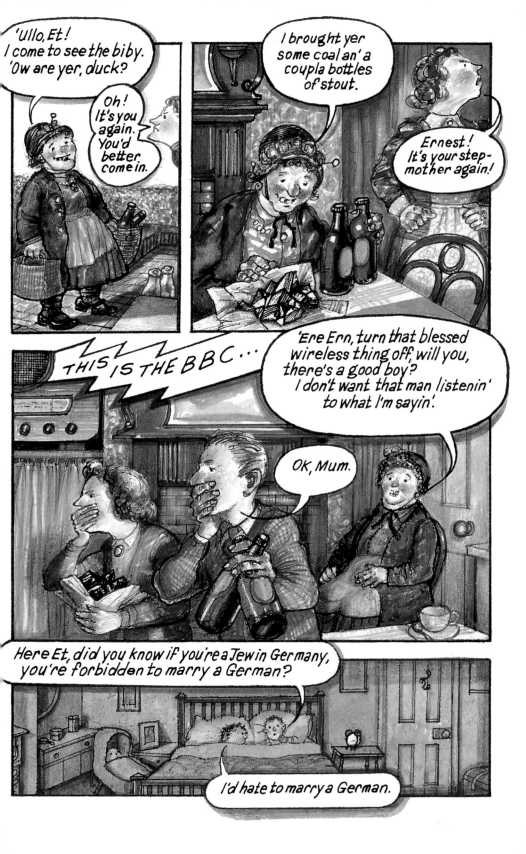

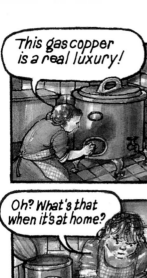

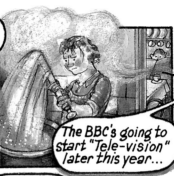

This gas copper is a real luxury!

Just turn the tap and strike a match!

The BBC's going to start "Tele-vision" later this year...

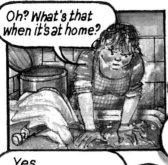

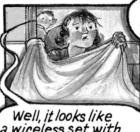

Oh? What's that when it's at home?

Well, it looks like a wireless set with pictures on top of it.

MOVING pictures? Talkies?

Yes. It'll be like going to the pictures without going out.

What? You'll just sit and look at it?

Yes.

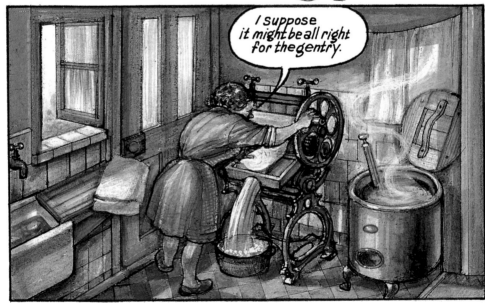

I suppose it might be all right for the gentry.

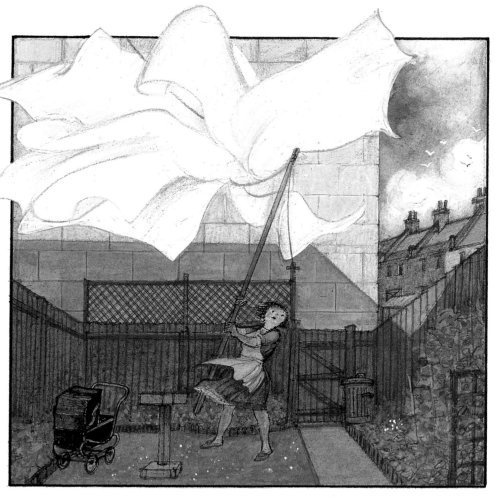

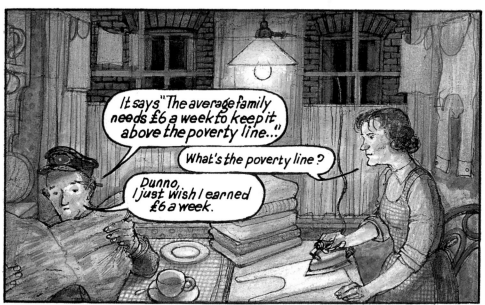

It says "The average family needs £6 a week to keep it above the poverty line..."

What's the poverty line?

Dunno, I just wish I earned £6 a week.

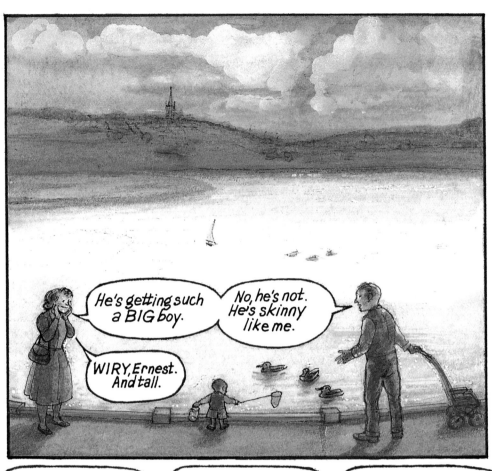

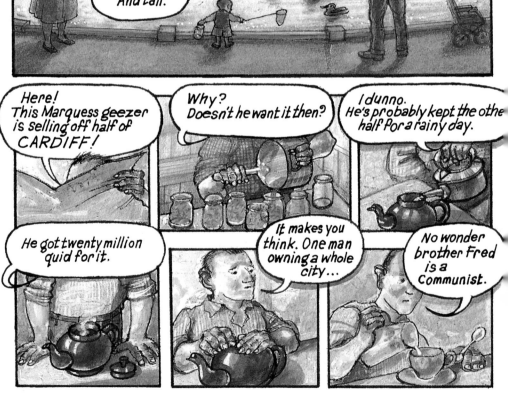

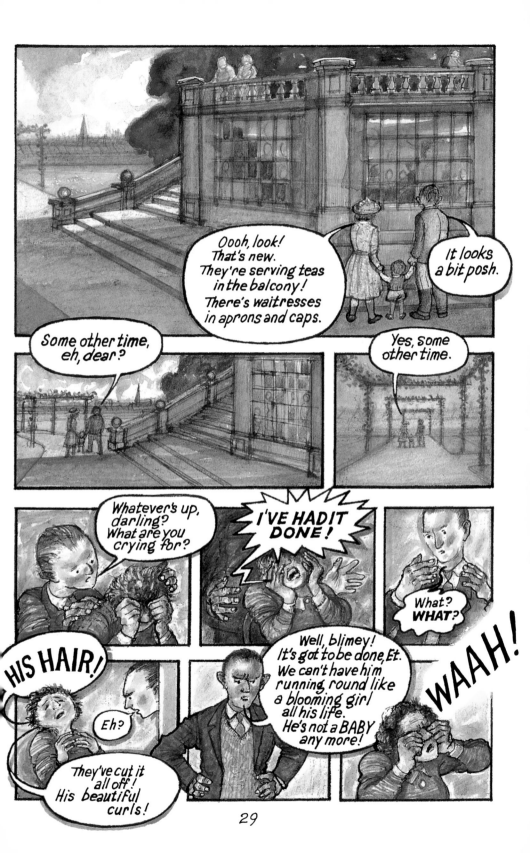

29

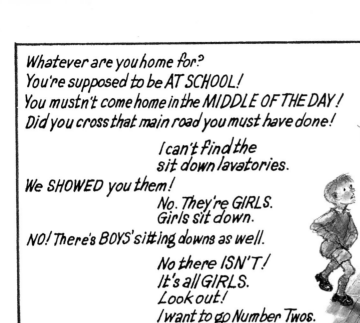

*Whatever are you home for?
You're supposed to be AT SCHOOL!
You mustn't come home in the MIDDLE OF THE DAY!
Did you cross that main road you must have done!*

*I can't find the
sit down lavatories.*

We SHOWED you them!

*No. They're GIRLS.
Girls sit down.*

NO! There's BOYS' sitting downs as well.

*No there ISN'T!
It's all GIRLS.
Look out!
I want to go Number Twos.*

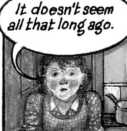

*Sounds like
that Hitler's
on the warpath
good and
proper.*

*Our George
was killed in
the last one.*

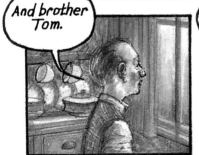

*And brother
Tom.*

*It doesn't seem
all that long ago.*

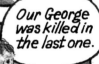

*Our poor old mother
never got over it.
She died at 4:*

*Mum!
What have I got to wear
red, white and blue
to school for?*

Because it's Empire Day.

What's empire?

*Do keep
STILL!*

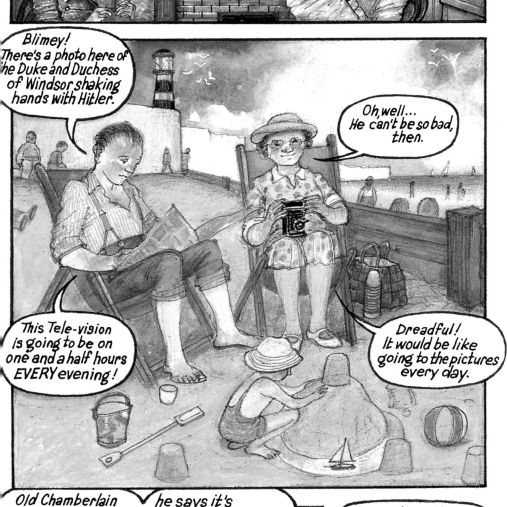

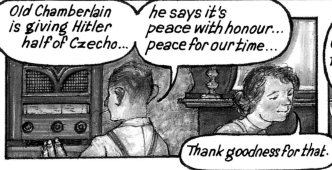

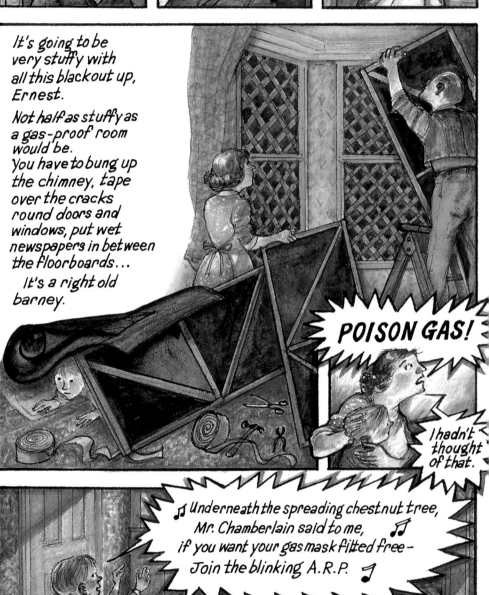

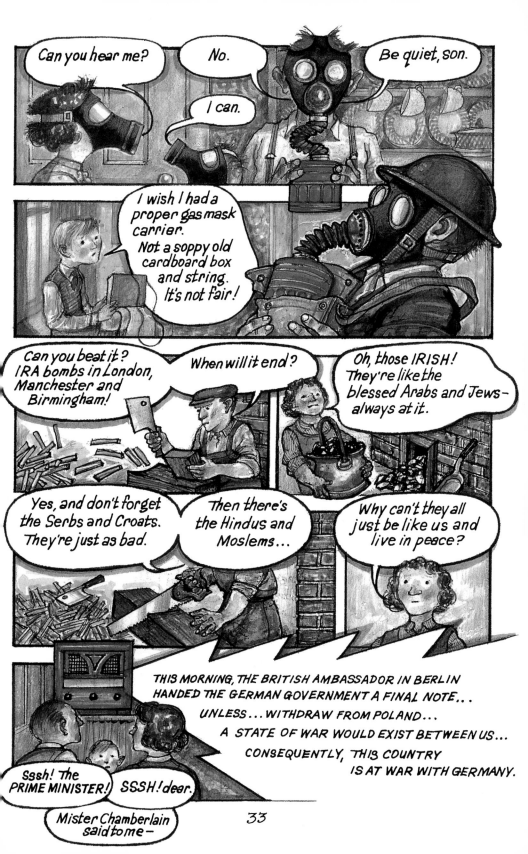

33

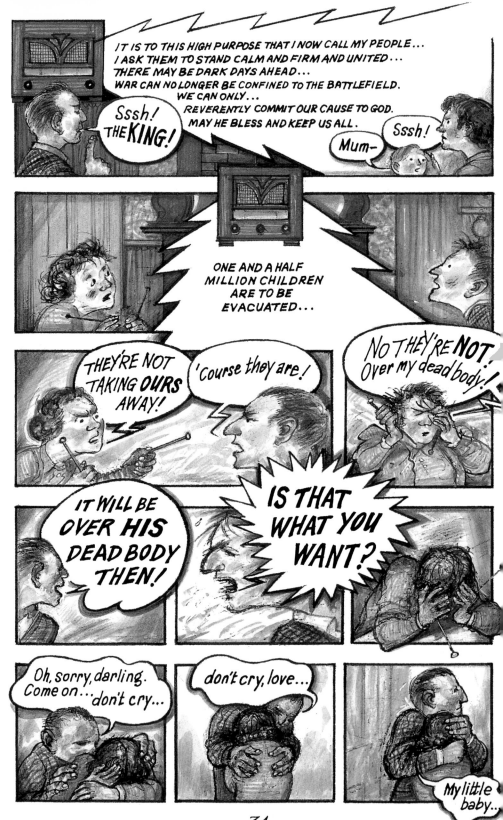

34

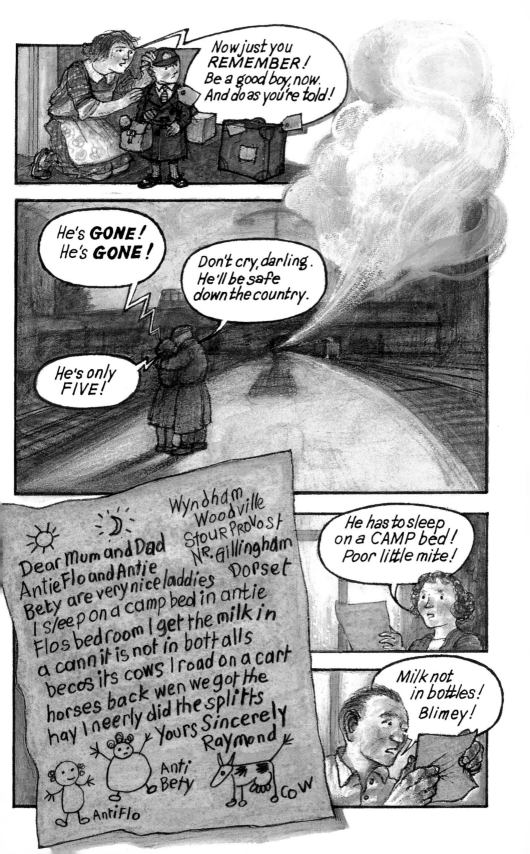

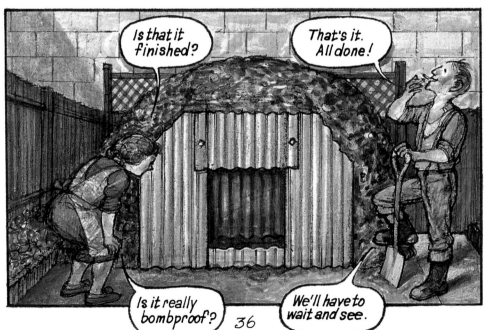

36

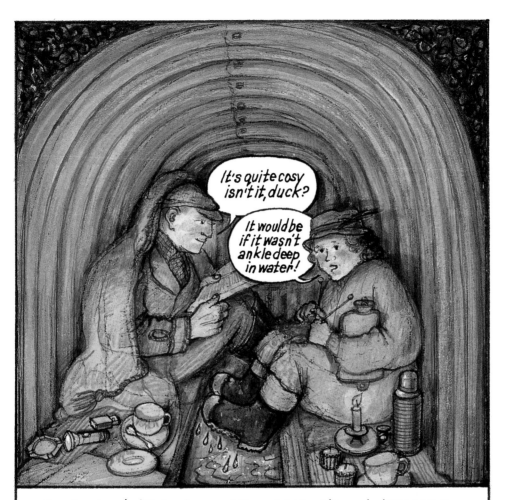

Russia's invaded Finland now. I thought they'd invaded POLAND?

Yes, they have. But you said GERMANY's invaded Poland?

Yes, that's right. Well, who was it invaded Czechoslovakia?

Germany. Germany's always invading someone.
I expect they'll invade Russia one day –

Cor blimey! Not likely!
They're IN LEAGUE! or Russia will invade Germany.

Oh don't be DAFT! If they ALL keep invading one another,
WE'LL end up invading someone.

Oh Et! You just don't
understand politics.

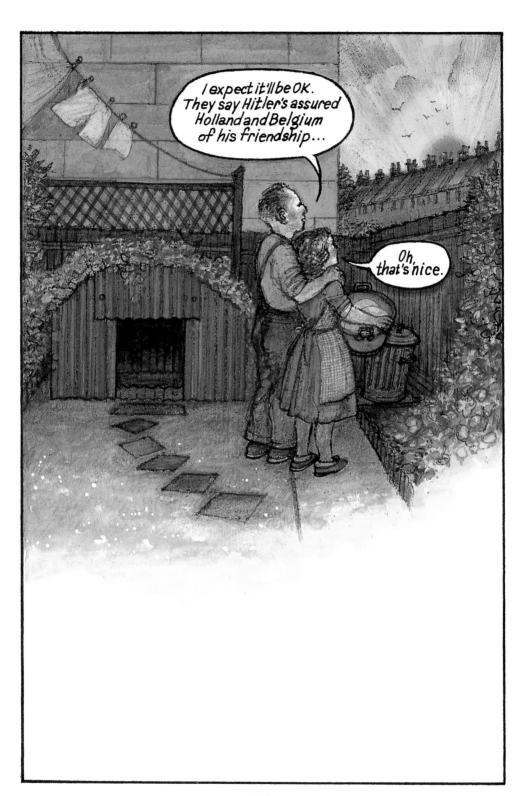

1940
~
1950

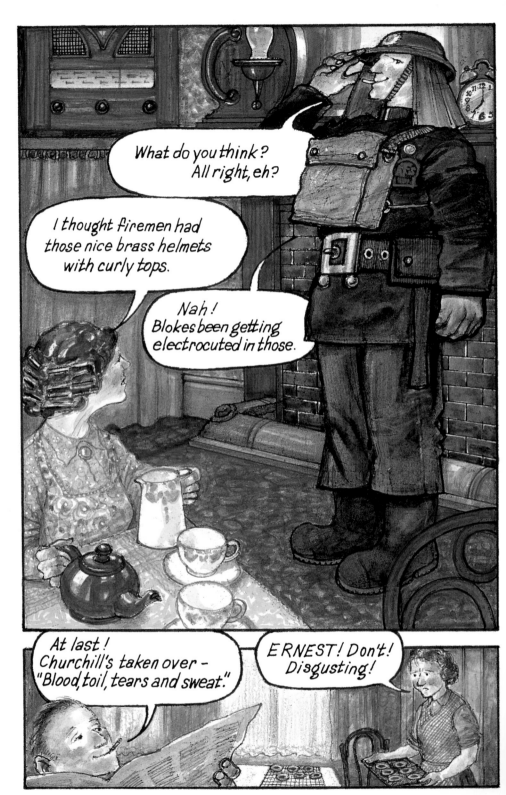

40

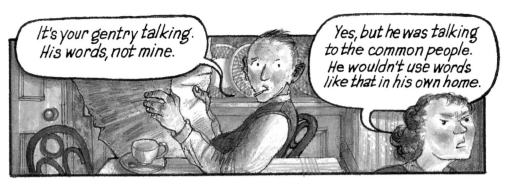

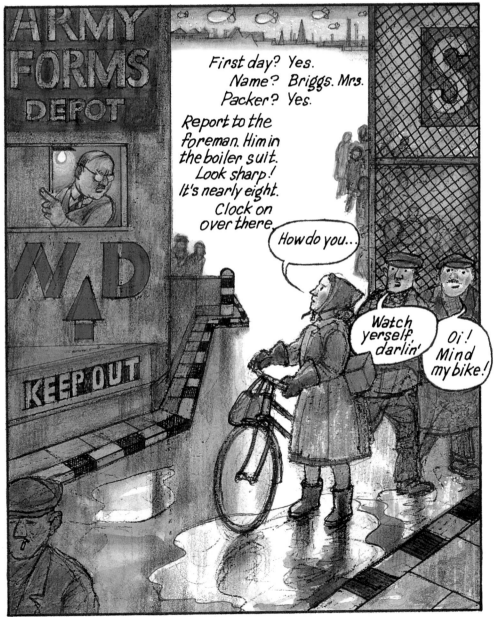

The battle for France is over...
the Battle of Britain is about to begin.
Upon this battle depends the survival
of Christian civilization.
The whole fury and might of the enemy
must, very soon, be turned on us.
Hitler knows that he will have to break us
in this island, or lose the war.

If we can stand up to him, all Europe
may be free and the life of the world
may move forward into broad sunlit uplands.

But, if we fail, the whole world
will sink into the abyss of a new dark age.
Let us, therefore, brace ourselves to our duty
and so bear ourselves that if the
British Empire last for a thousand years,
men will still say:

THIS was their finest hour.

Broad sunlit uplands!

Good old Winston!
Our finest hour!

I expect Jerry will be coming over soon

They're starting to take away our nice gate and railings.

I'll make a wooden gate.

Shame.

They want saucepans, too. They make them into Spitfires.

Funny to think of our front gate being a Spitfire.

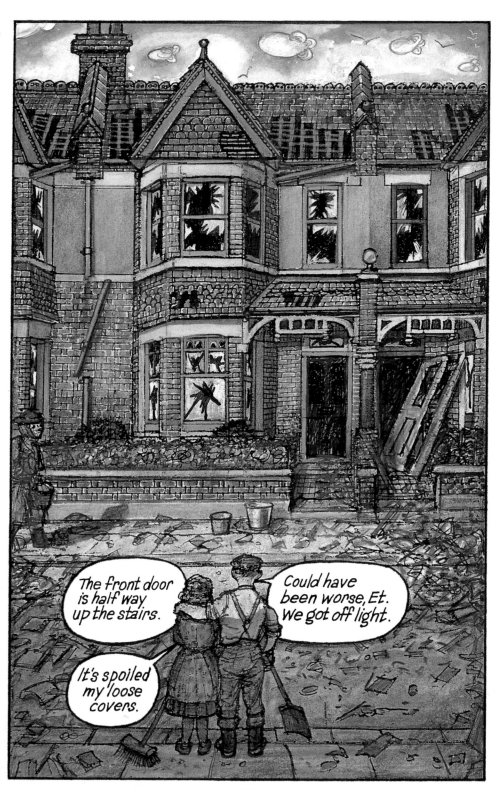

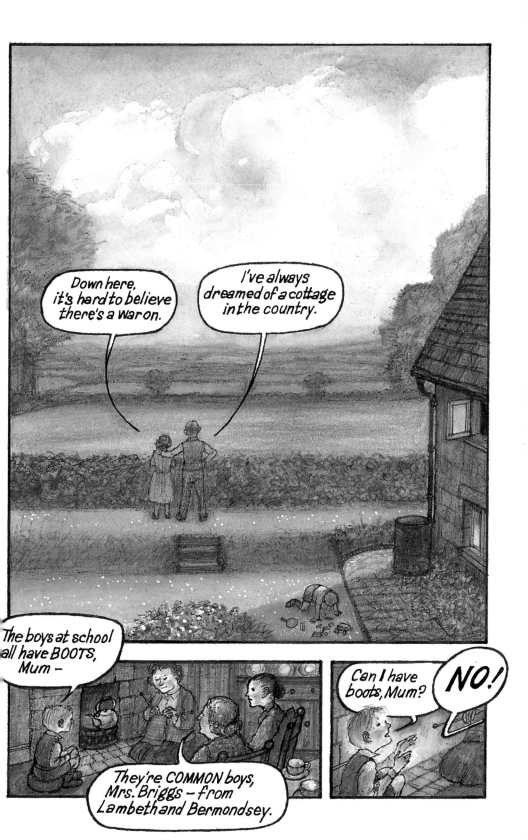

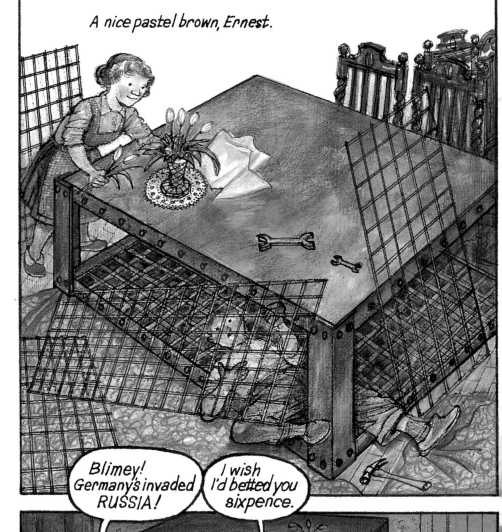

46

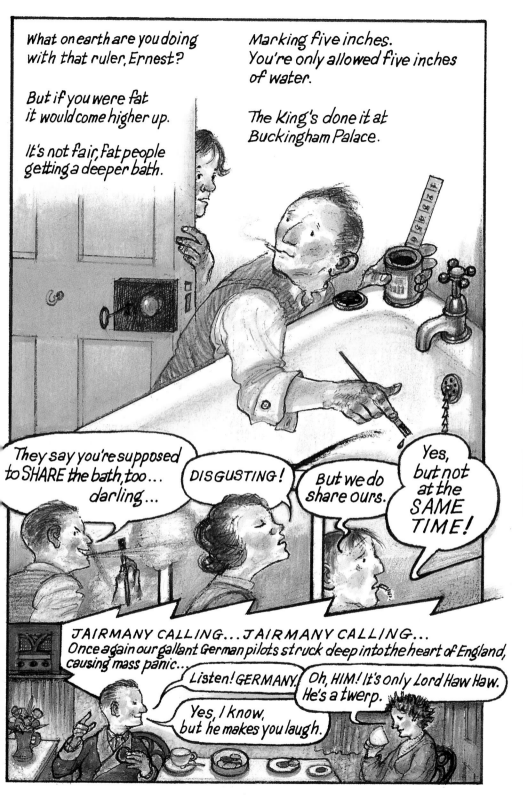

47

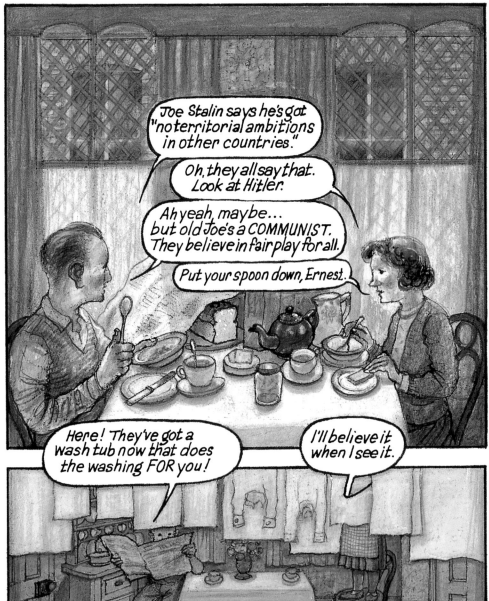

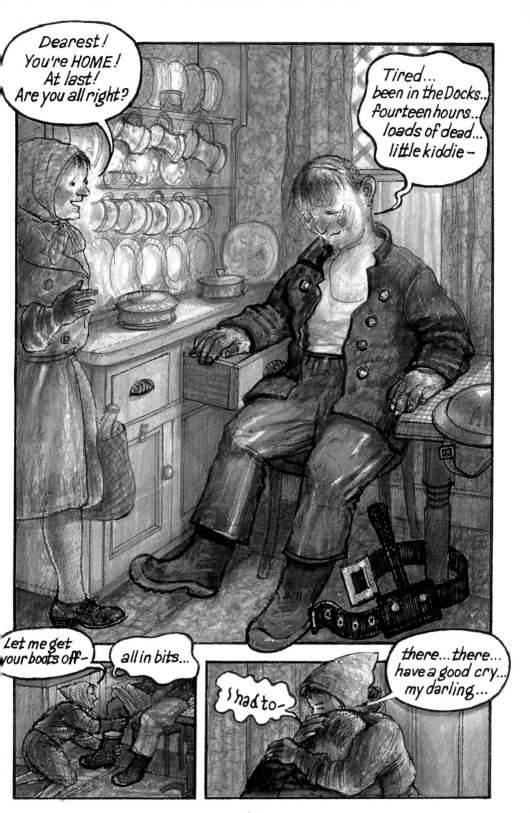

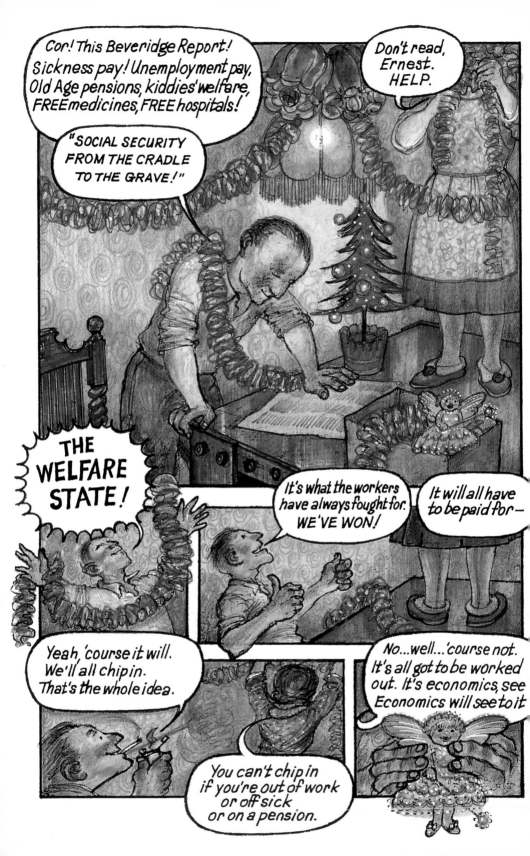

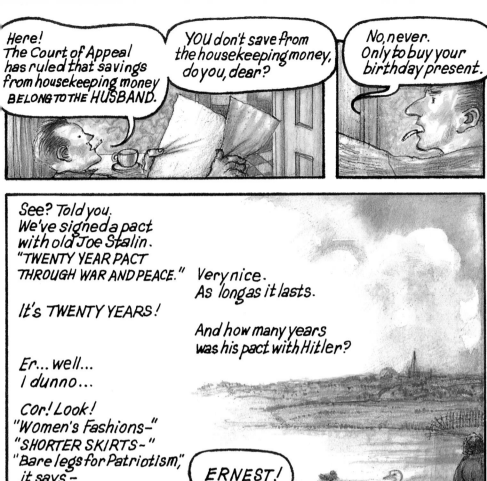

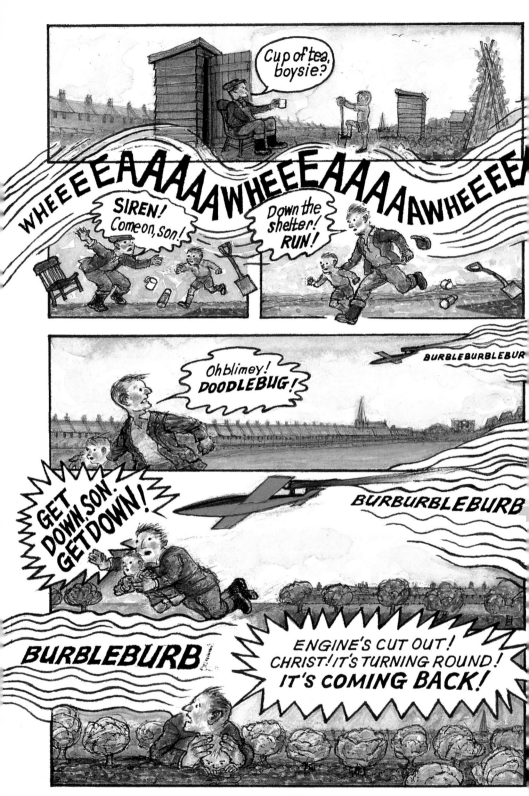

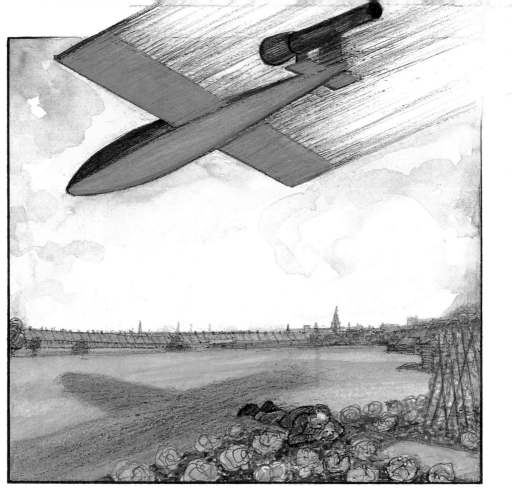

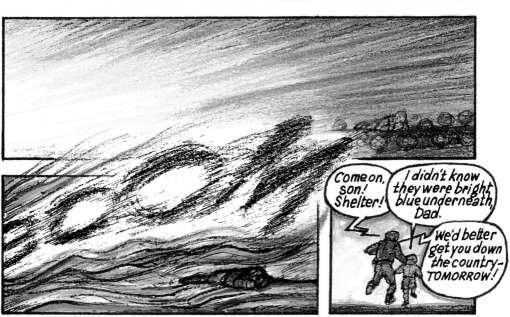

Come on, son! Shelter!

I didn't know they were bright blue underneath, Dad.

We'd better get you down the country— TOMORROW!

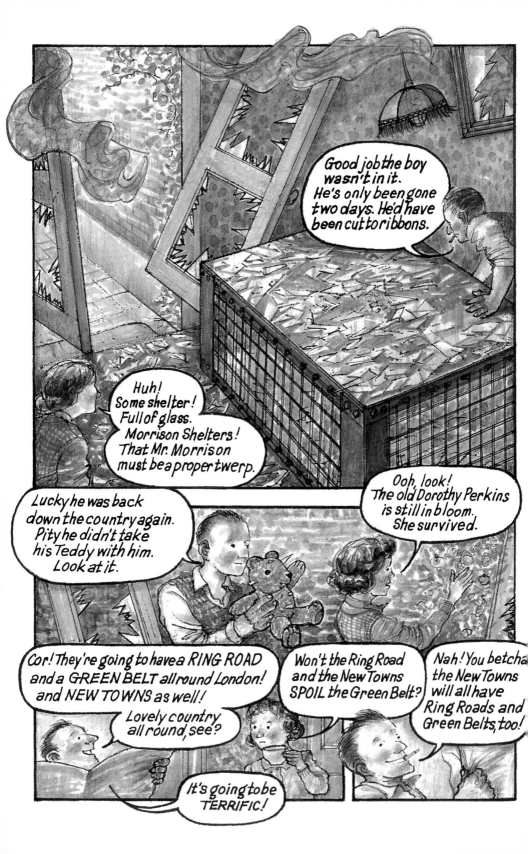

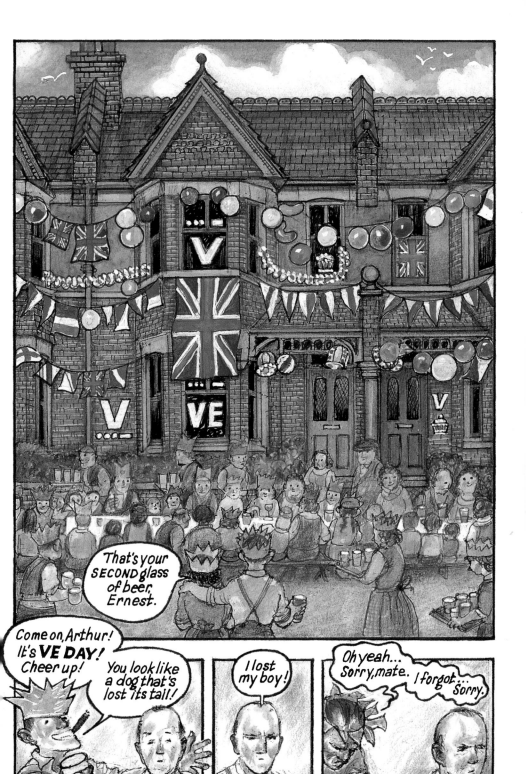

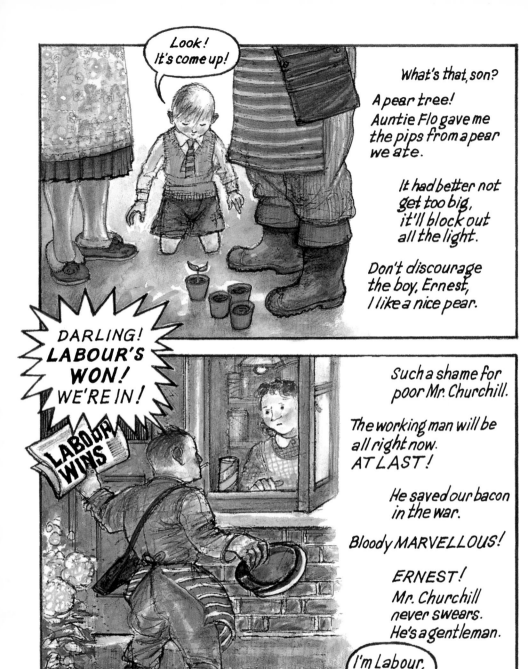

56

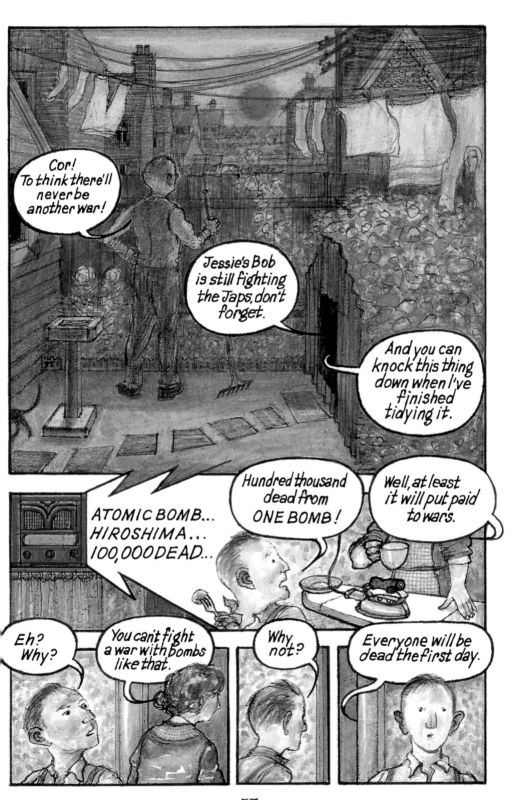

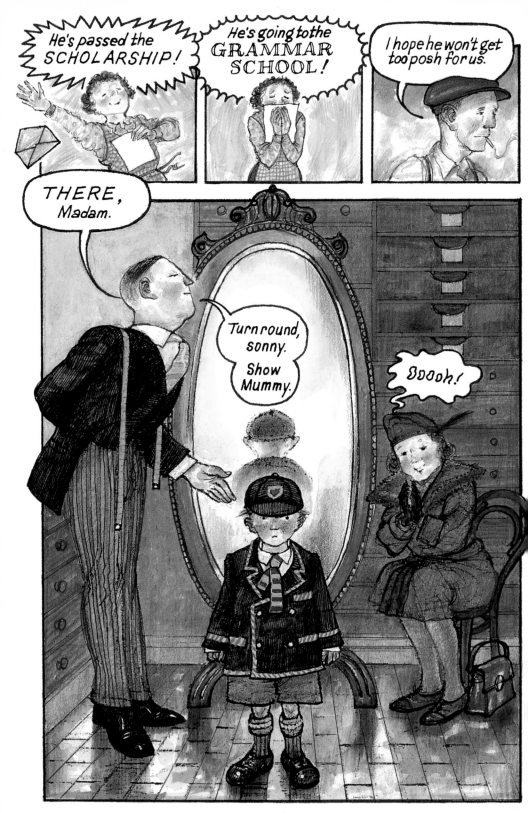

58

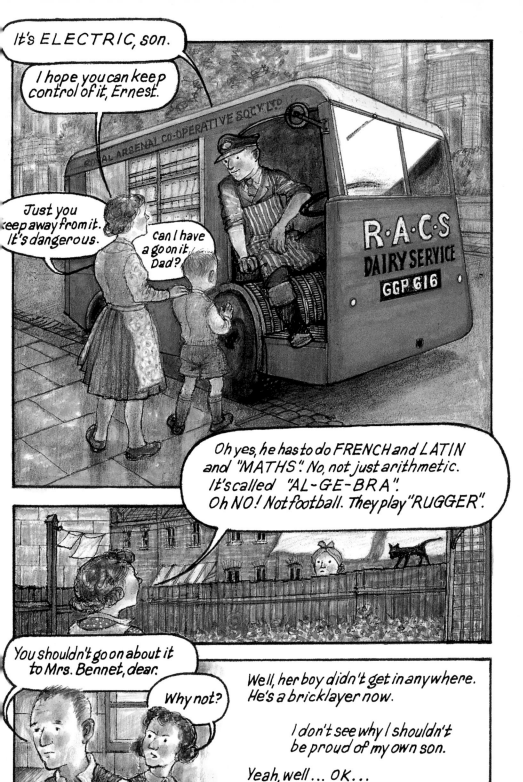

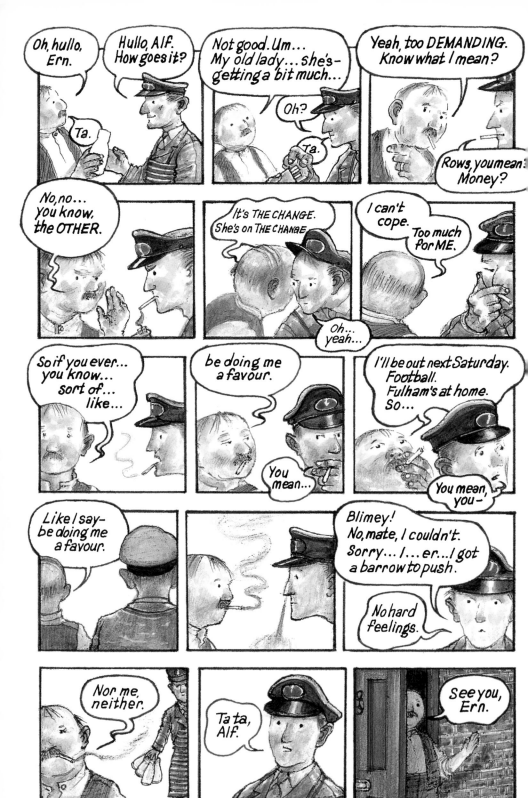

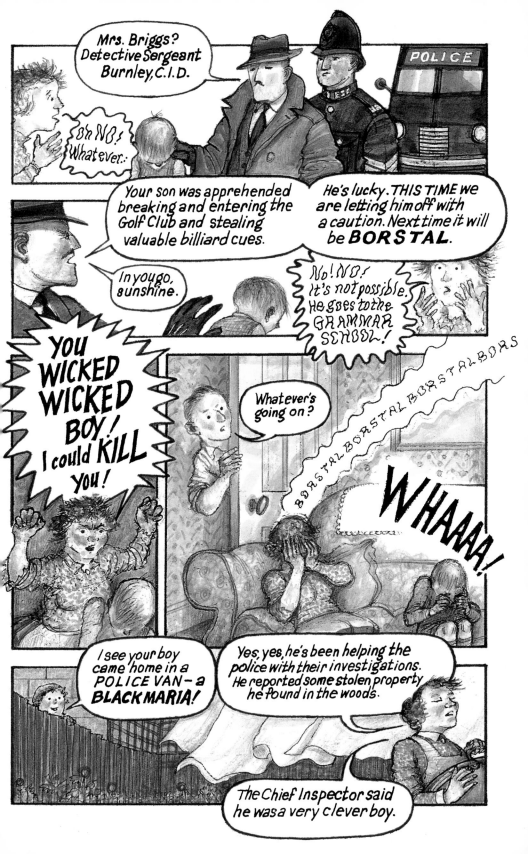

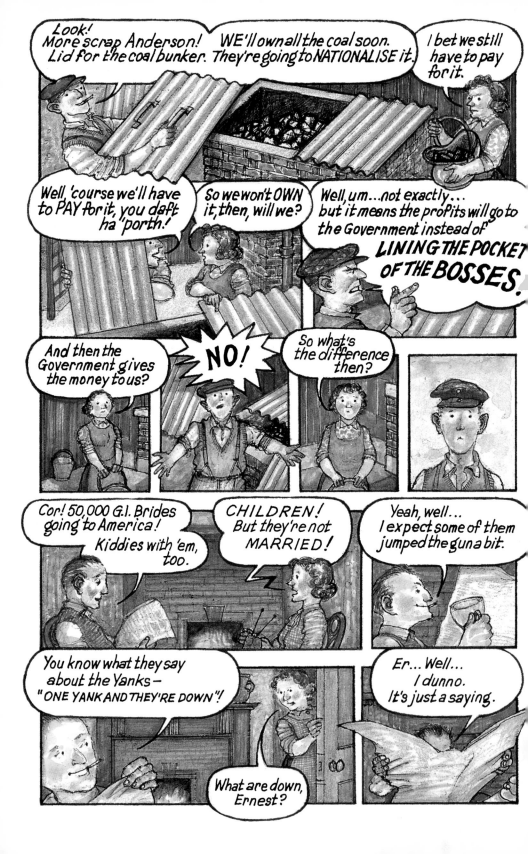

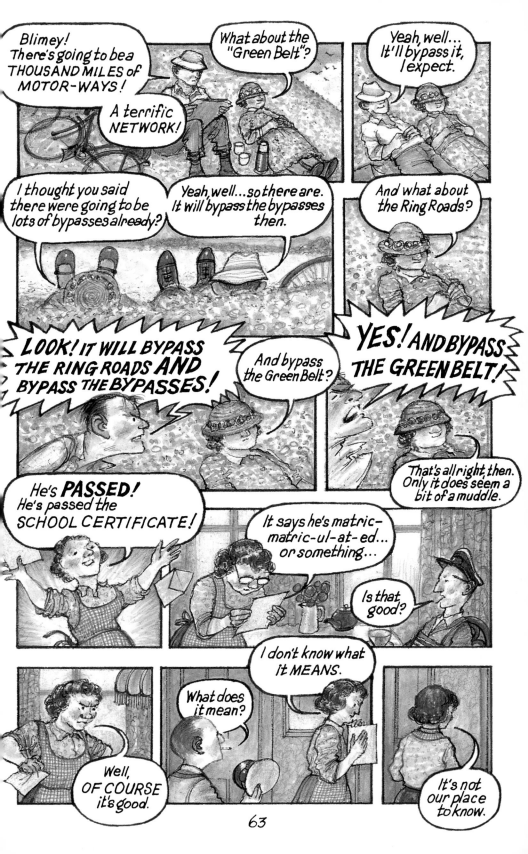

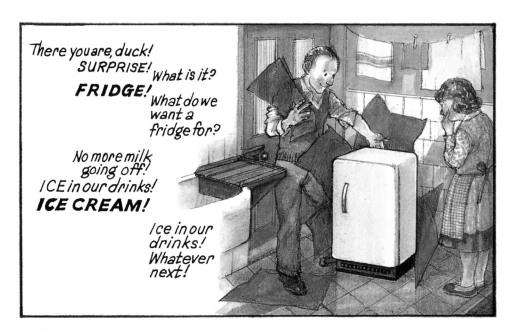

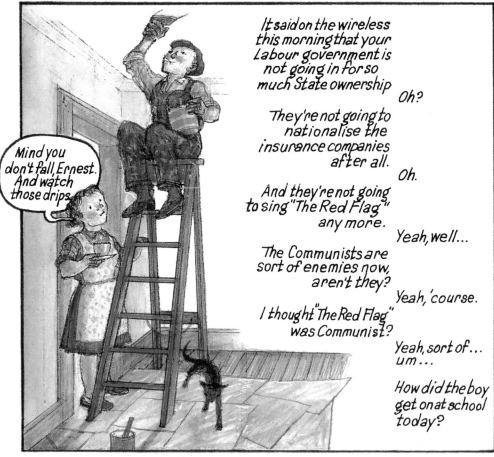

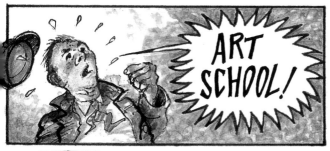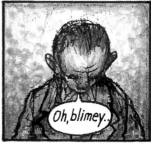

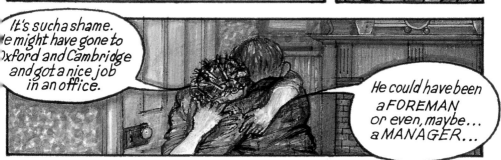

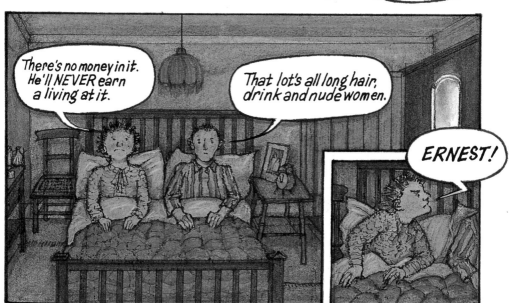

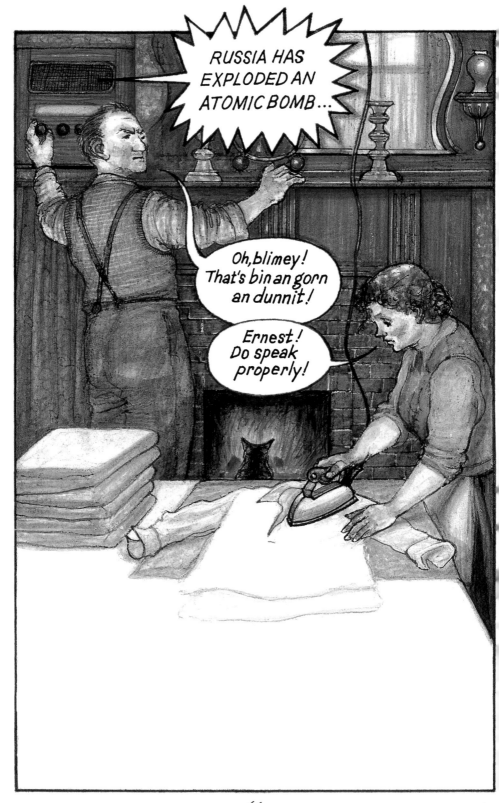

1950
~
1960

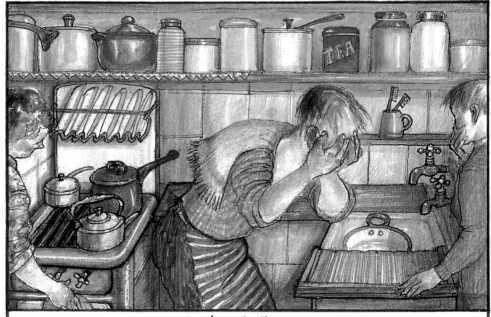

Dad... Hullo.

Dad...
When you come
home from work... Yeah?

Why don't you wash
in the BATHROOM? Blimey son! Not likely! I'm filthy, look.

Yes, I know but that is
what the bathroom is FOR! No. Not in the BATHROOM.
Not in THIS state.

But this is the KITCHEN!
All the FOOD is in HERE!
Mum is trying to COOK! No. I couldn't, son.
Not in the BATHROOM.

That laundrette is a Godsend!
I did the whole blessed lot
for two and nine.
AND it's all bone DRY!

We could chuck out the mangle and the copper.
I could get an electric thermostat for the tank.
Hot water in the SUMMER time!

MODERN!

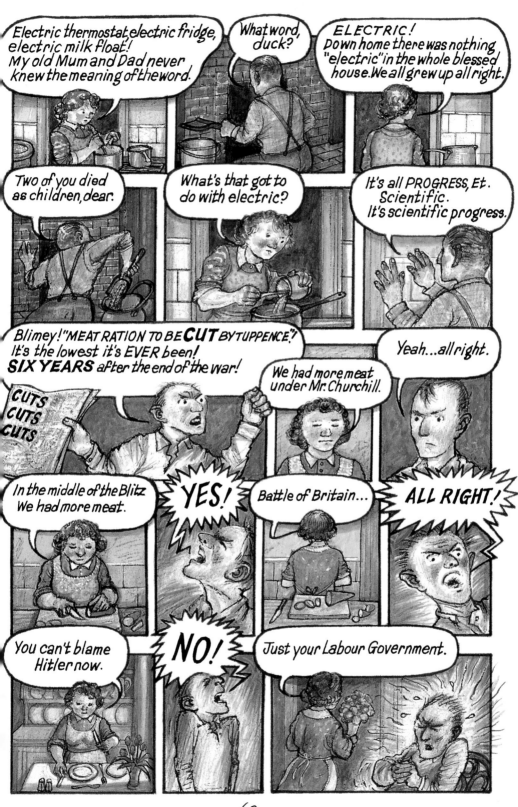

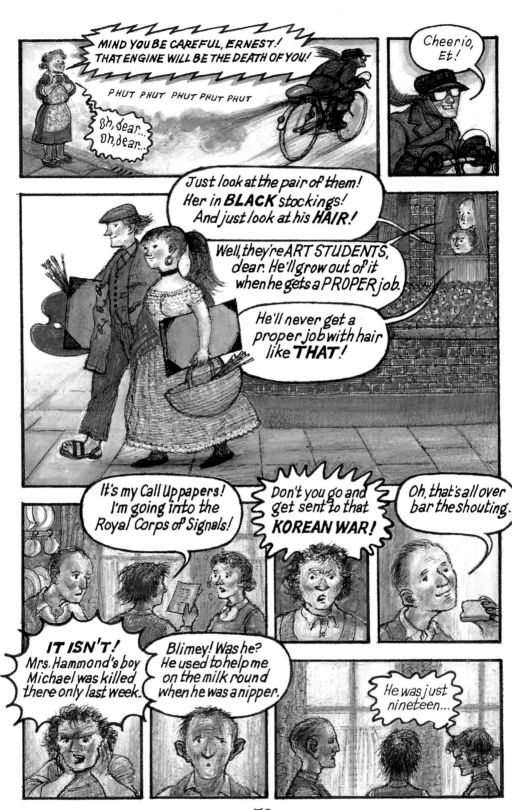

70

72

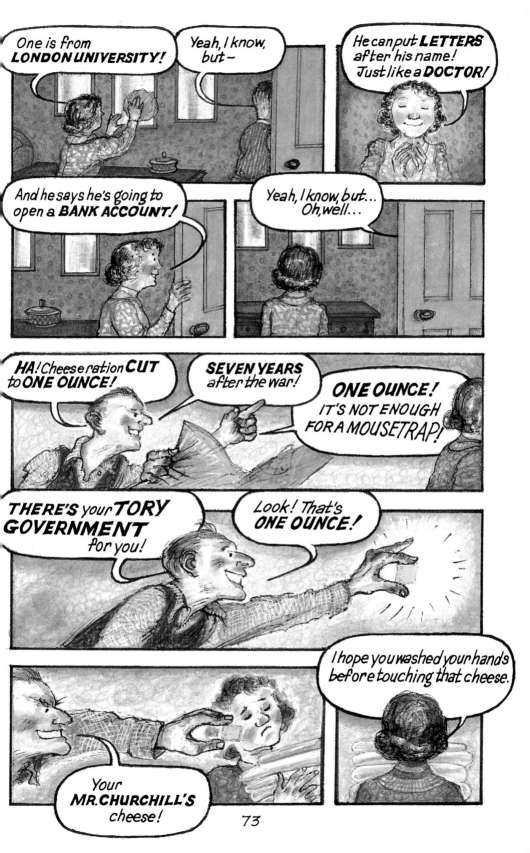

73

Ooh, dear...

What shall I do if it rings when you're out?

Well, ANSWER IT! you daft ha'porth!

I don't think I like it.

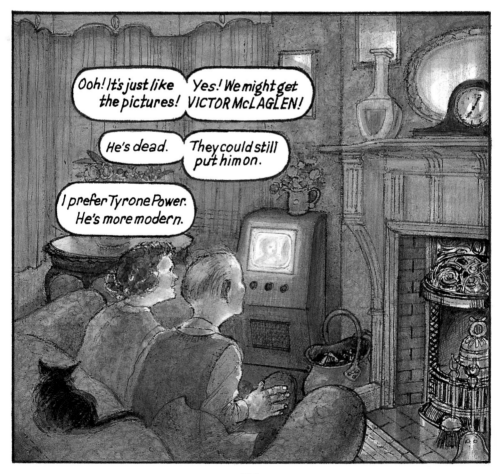
Ooh! It's just like the pictures!

Yes! We might get VICTOR McLAGLEN!

He's dead.

They could still put him on.

I prefer Tyrone Power. He's more modern.

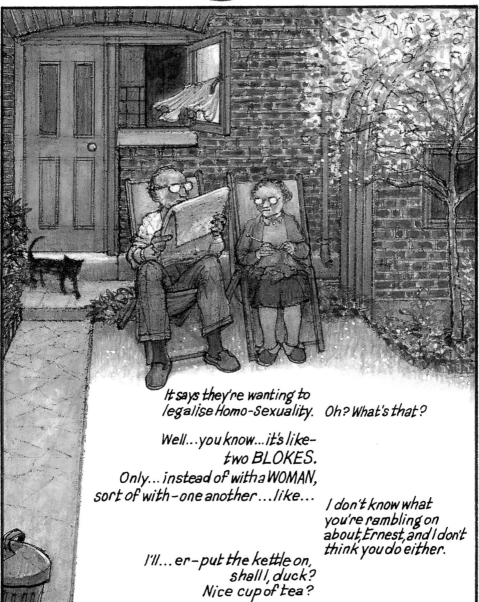

75

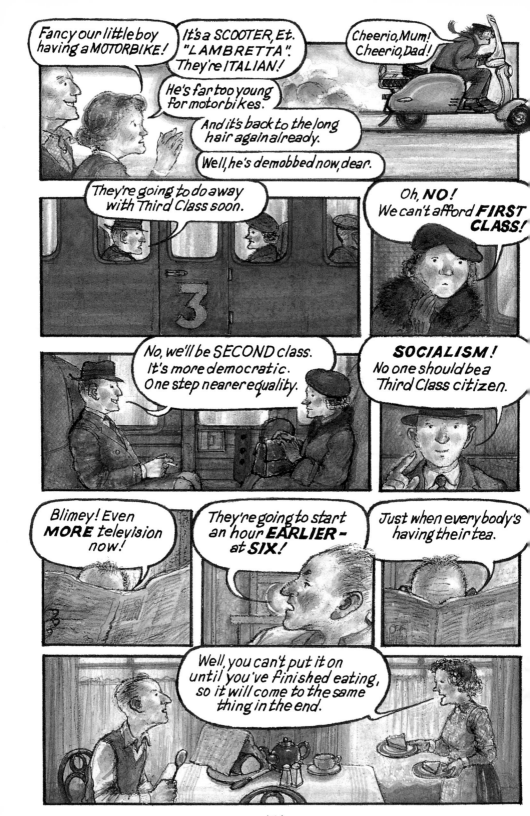

We should have this HI-FI now, duck.　Oh? What's that?

Well, it's sort of like having two wirelesses on at once. One for each ear.　Extravagant.

It's a radiogram as well, though. Plays records.　We haven't got any records.

No, but if we had, you could put them on and hear the STEREO.　The what?

The STEREO. It comes out in STEREO.　What does?

The music from the HI-FI. It's "PAN-OR-AM-IC SOUND" it says. 3D.　Three dee?

Yeah, 3D, 'course.　I don't think I want to bother with it.

Here! This soppy bishop says: "Mothers who work full-time are the enemies of family life."

It's all right for *HIM*, living in a *PALACE* with *SERVANTS!*

He was brought up to different standards, Ernest. He's a *GENTLEMAN* Christian.

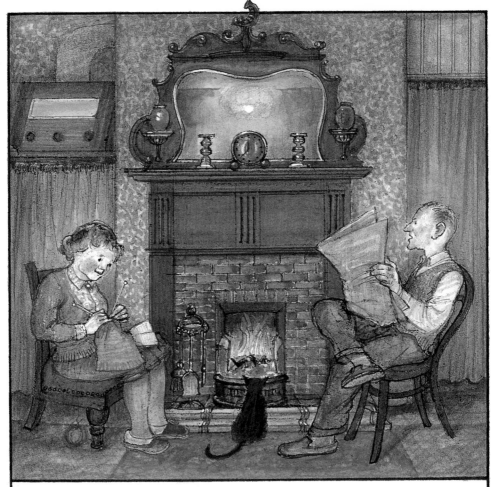

Here Et, listen. It says we've got to be **HIP**.

What?

GROOVY, babe. And **REAL COOL**.

Just talk sense, Ernest.

We've got to **HANG LOOSE** with the **CATS**.

Cats?

YEAH, MAN!

Ernest! Go to bed.
You're overtired.
I'll make the cocoa.

You're a **SQUARE**, baby.

Oh, Ernest...
When will you grow up?

1960
~
1970

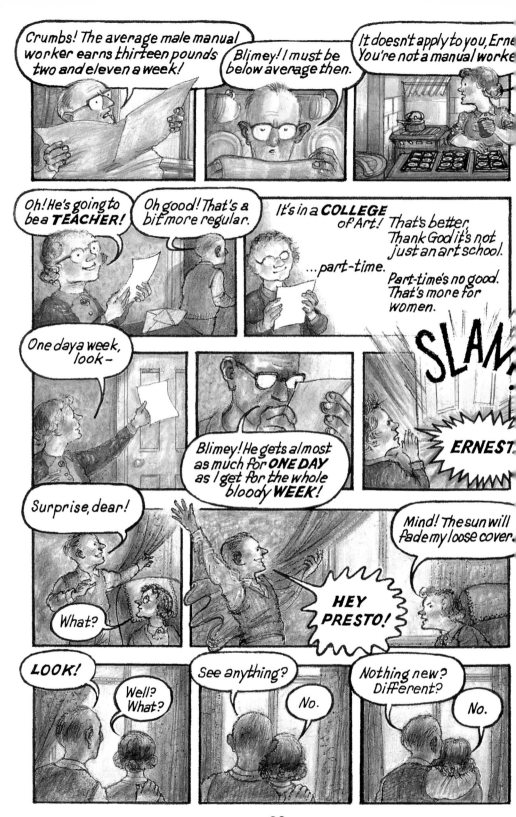

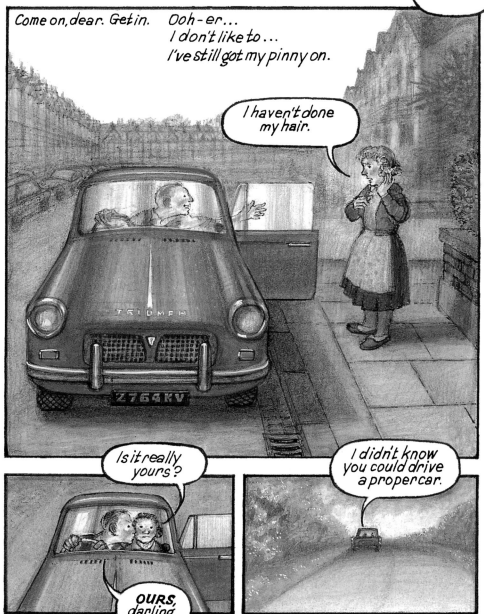

81

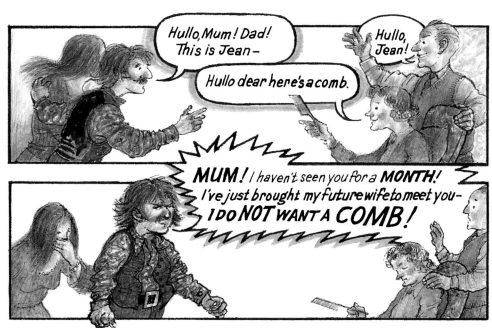

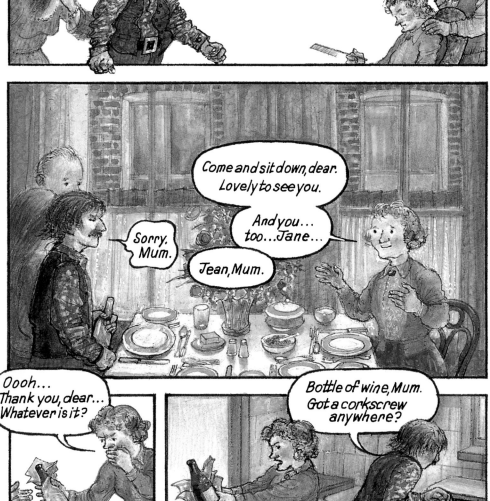

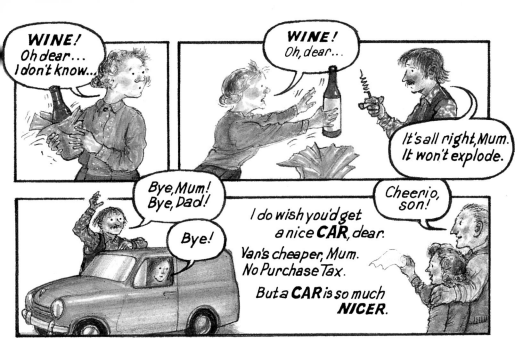

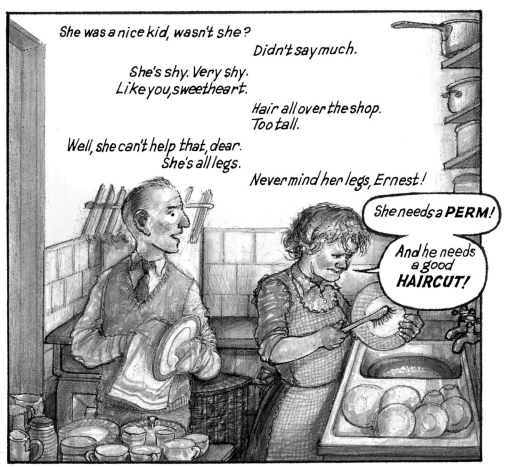

OH, NO! He says they're going to get married in a **REGISTRY OFFICE!**

Well, that's the modern way, Et.

Horrible!

Yes, but neither of them is religious.

I don't want him to be **RELIGIOUS!**

It's so much... nicer...

I just want him to get married in a **CHURCH!**

When are you going to start a family, dear?

Well... don't know really, Mum. Probably not at all.

Goodness me! Why ever not? I want to be a granny.

Well, Jean's got problems, Mum. Brain trouble.

BRAIN TROUBLE!

Yeah...well...that's just what I call it - as a sort of...joke...
She goes in and out of the loony bin.

You mean... she's - mental?

Yeah. That's one word for it. The other word is - Schizophrenia.

Oh, dear! Poor thing!

So I won't be a granny after all?

Never mind, Mum.

84

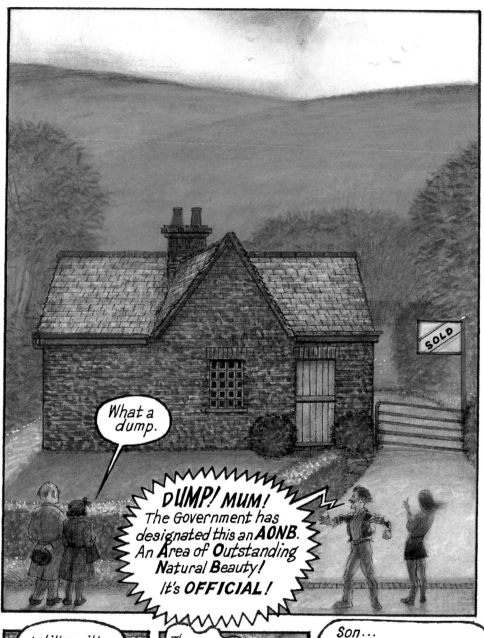

What a dump.

DUMP! MUM! The Government has designated this an **AONB**. An **A**rea of **O**utstanding **N**atural **B**eauty! It's **OFFICIAL!**

I still say it's a dump.

The South Downs are at the end of the garden!

I give up... I give up...

Son... It's the sort of place I've always dreamed about.

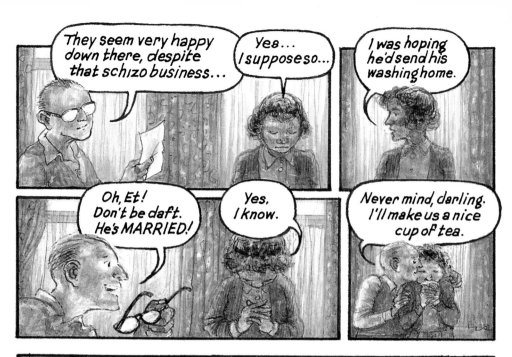

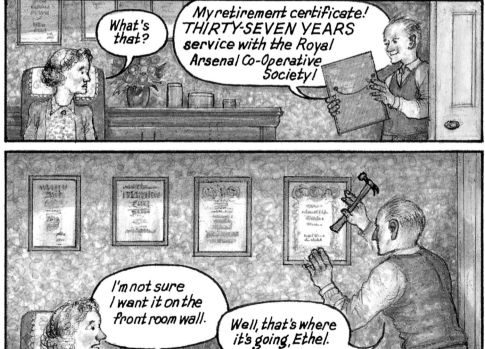

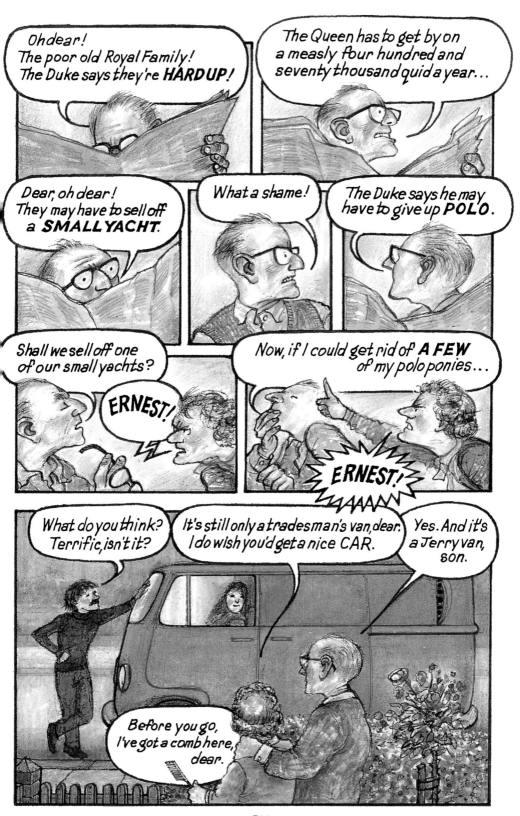

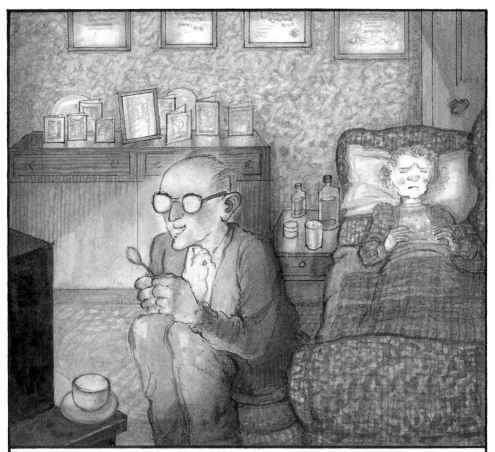

MAN ON THE MOON, Et!

Oh?

FANTASTIC, eh?

What's he doing there?

Well, just walking about a bit.

Then what?

Well...come back, I suppose...

Perhaps they'll have a picnic.
That would be nice.

I think the tea would blow away
when it came out of the thermos.

Why? Is it windy up there?

No, it's gravity, dear.

Oh, I see.

Look! He's going to pick up
some pebbles...to take home.

Just like kiddies at the seaside.
Turn it off, will you?

1970
~
1971

Decimal Currency starts next week! Oh yes, I've heard about it on the television.

It's dead simple! See - a bob equals **FIVE** New Pence. Two bob is **TEN** New Pence. What's a ha'penny?

There isn't one - oh yes, there is! Half a New Pence - looks like a farthing. What about threepenny bits?

Gone, duck. A tanner is two and a half New Pence. And what about half a crown?

Er...well...that'll be - two bob equals ten New Pence, a tanner equals two and a half New Pence, so ten plus two and a half is...twelve and a half New Pence. Easy! What's a penny?

An **OLD** penny...well...a shilling is five New Pence, so twelve old pennies equals five **NEW** Pence, so **ONE** old penny is...twelve into five - Um... How many shillings are there in the pound now?

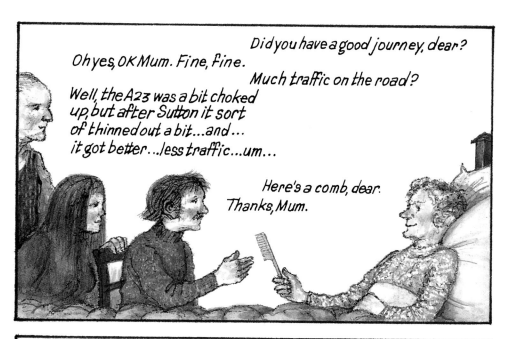

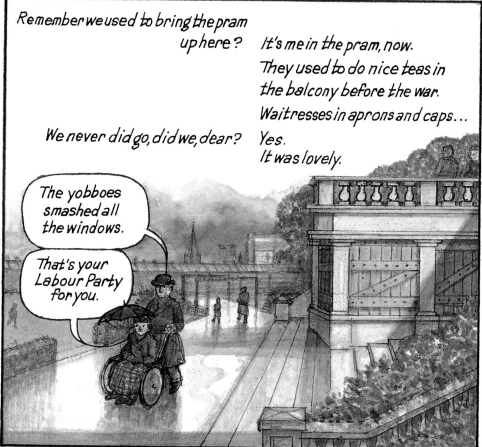

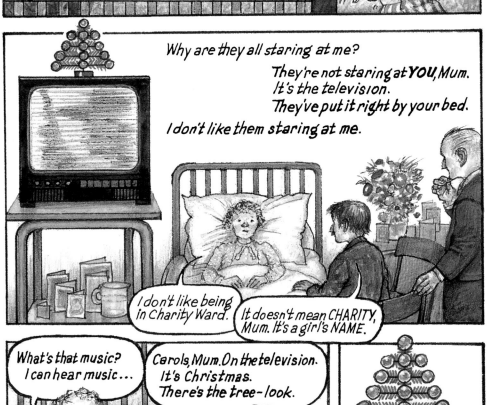

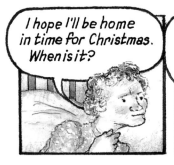

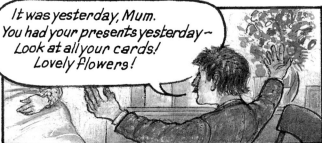

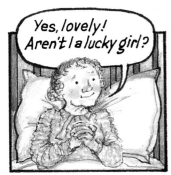

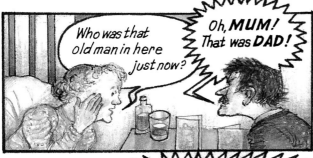

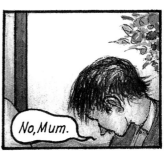

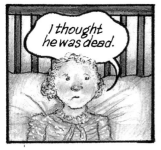

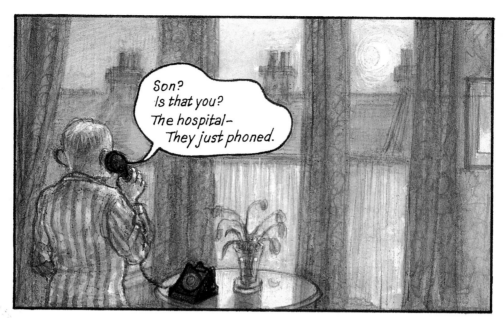

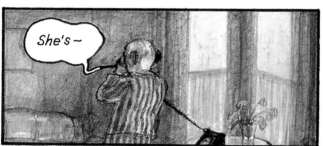

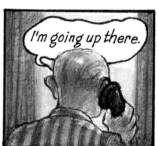

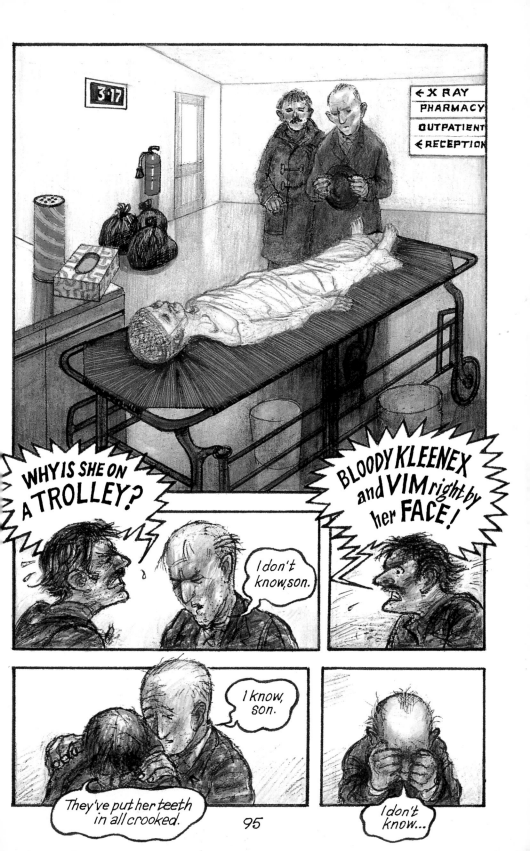

95

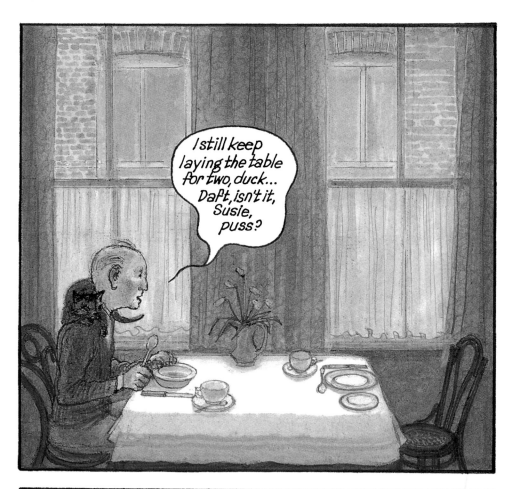

96

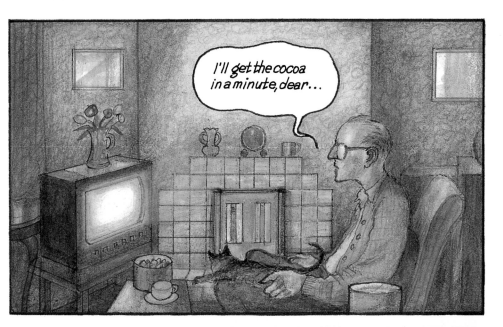

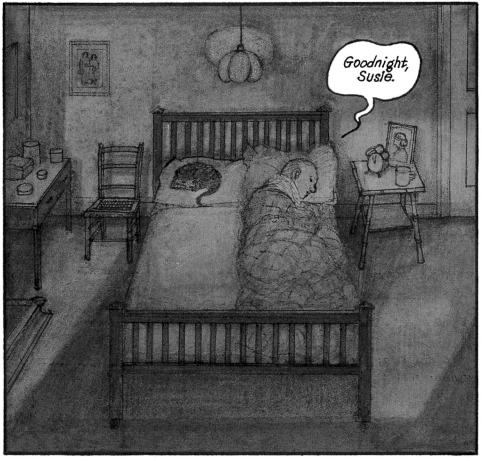

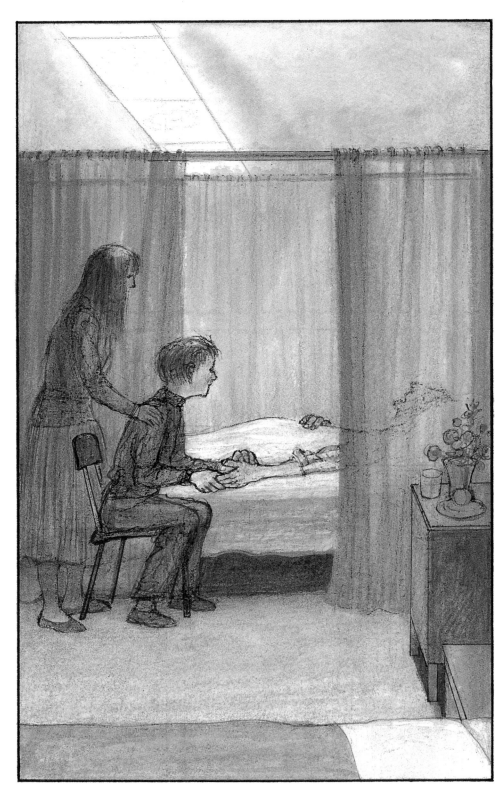

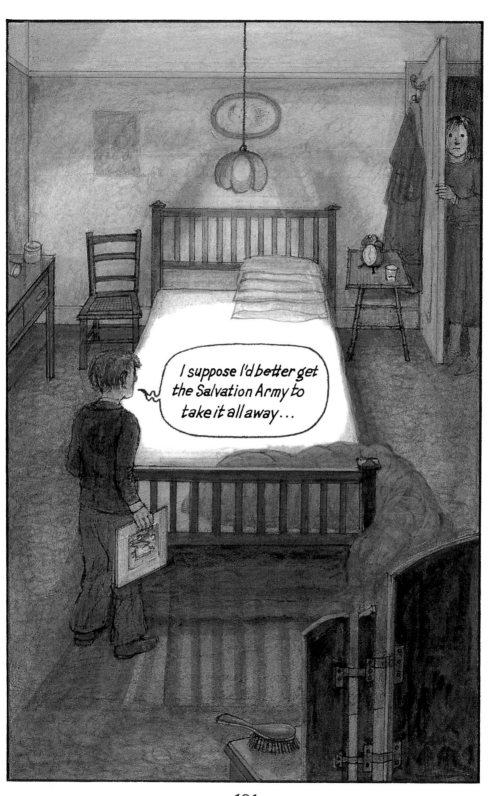

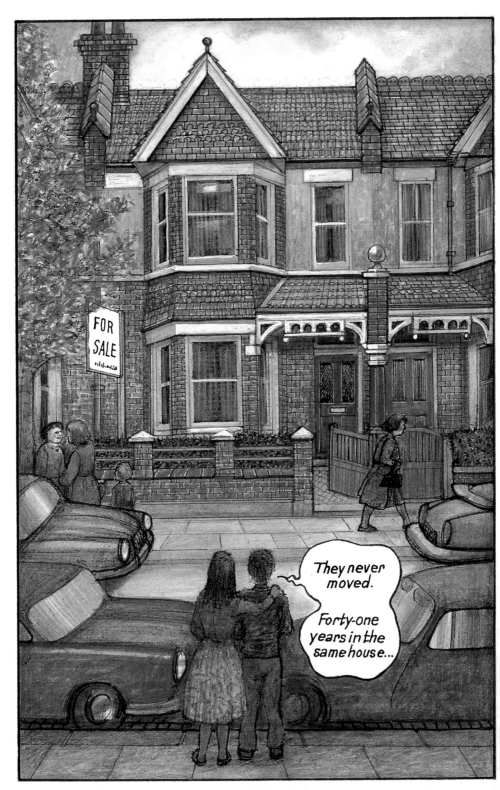

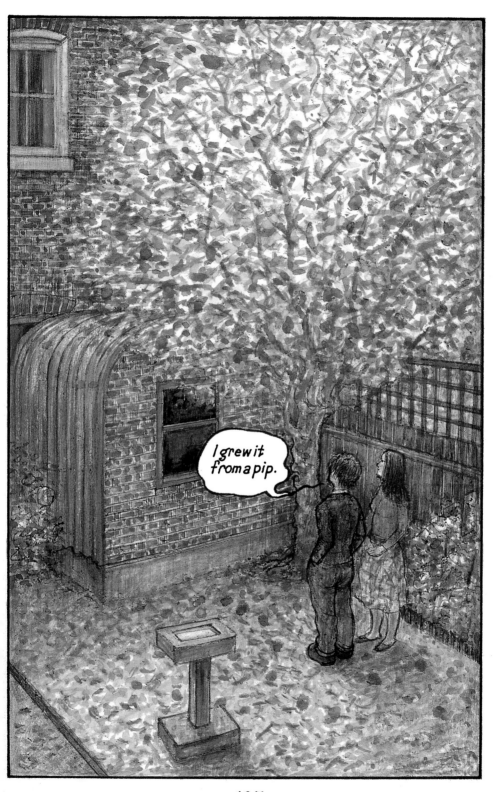

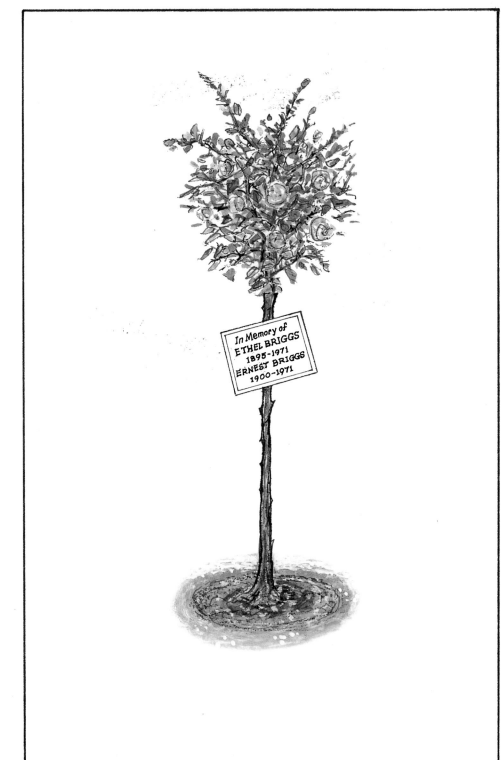